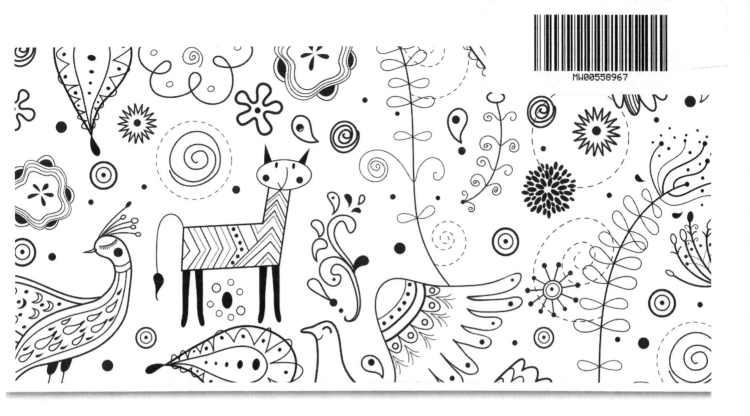

This book is given with love to my friend

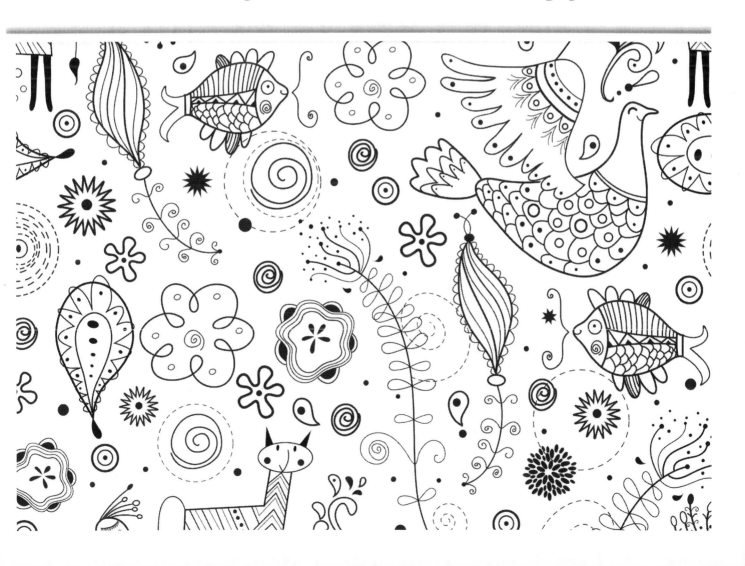

Love You Friend
The Perfect Anti-Stress Colouring Book For Friends

First published in the United Kingdom in 2015 by
Bell & Mackenzie Publishing Limited

ISBN: 978-1-910771-39-6

A CIP catalogue record of this book is available from the British Library

Created by Christina Rose
Contributors: Shutterstock/Tanor, Shutterstock/MariStep, Shutterstock/tets, Shutterstock/Fears, Shutterstock/bekulnis, Shutterstock/ihor_seamless, Shutterstock/IrinaKrivoruchko, Shutterstock/Tokar Nadezda, Shutterstock/Roman Poljak, Shutterstock/An Vino, Shutterstock/abdrashitova svetlana, Shutterstock/Snezh, Shutterstock/Linett, Shutterstock/blackstroke, Shutterstock/Lidia Puica.

www.bellmackenzie.com

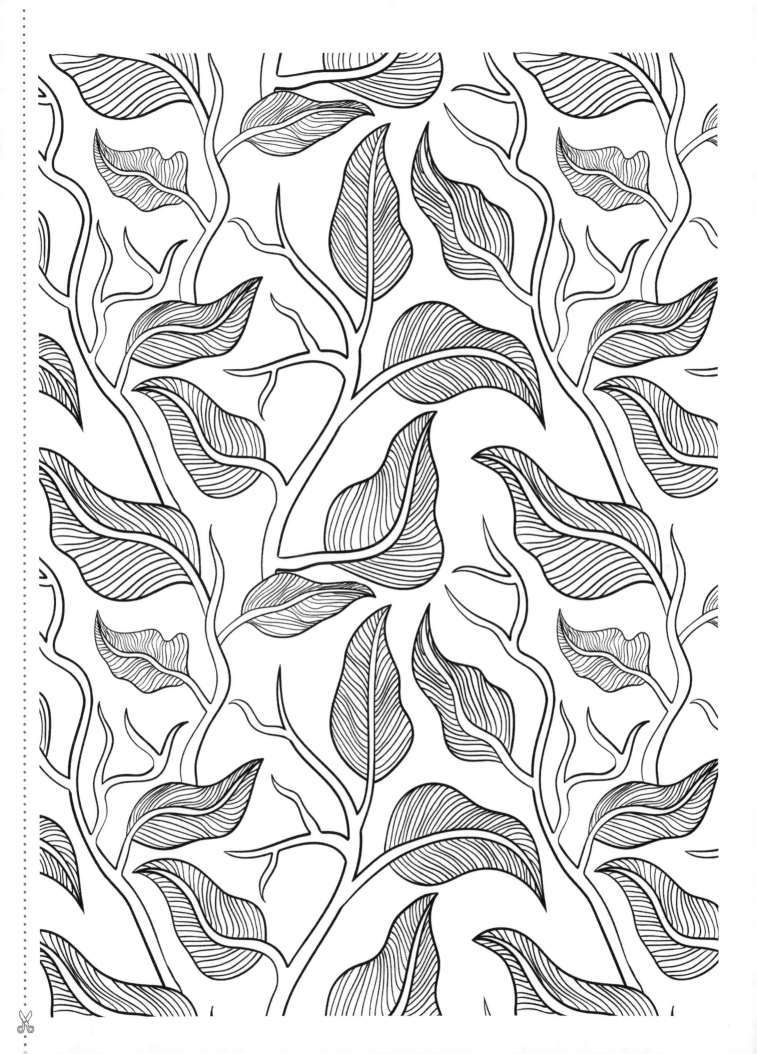

One of the most beautiful qualities of true friendship is to understand and to be understood.

Lucius Annaeus Seneca

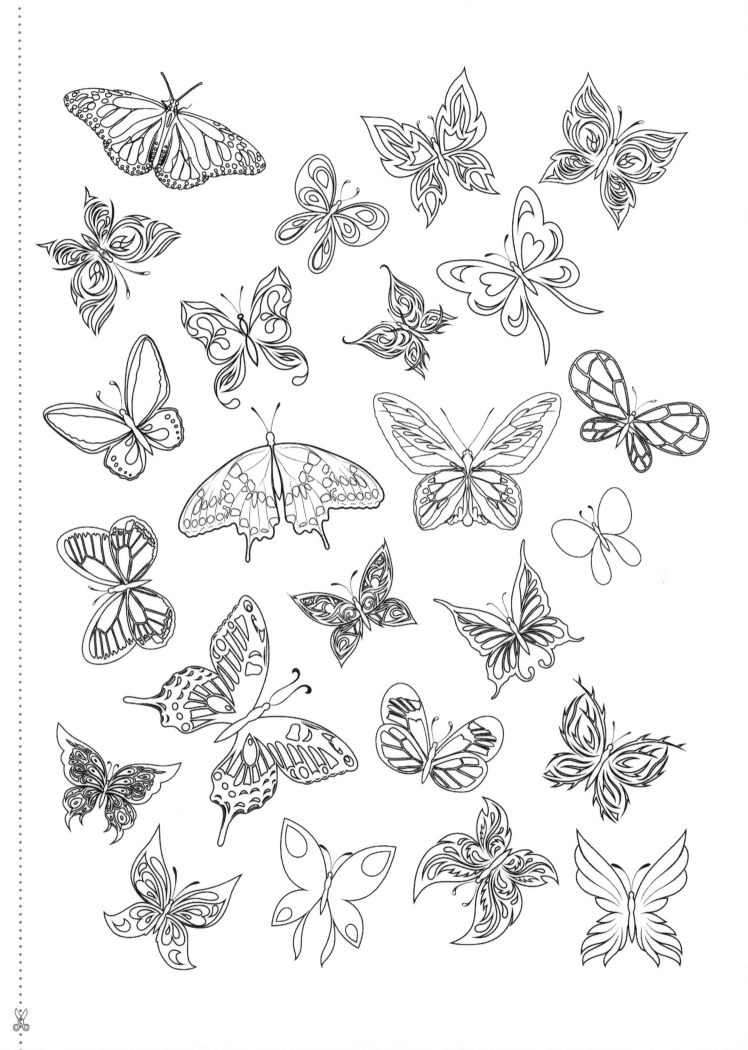

The greatest gift of life is friendship,
and I have received it.

Hubert H. Humphrey

Walking with a friend in the dark is better than walking alone in the light.

Helen Keller

A real friend is one who walks in when the rest of the world walks out.

Walter Winchell

I cannot even imagine where I would be today were it not for that handful of friends who have given me a heart full of joy. Let's face it, friends make life a lot more fun.

Charles R. Swindoll

It is one of the blessings of old friends that you can afford to be stupid with them.

Ralph Waldo Emerson

Friendship... is not something you learn in school. But if you haven't learned the meaning of friendship, you really haven't learned anything.

Muhammad Ali

A single rose can be my garden... a single friend, my world.

Leo Buscaglia

Sometimes being a friend means mastering the art of timing. There is a time for silence. A time to let go and allow people to hurl themselves into their own destiny. And a time to prepare to pick up the pieces when it's all over.

Octavia Butler

Friends show their love in times of trouble, not in happiness.

Euripides

Love is the only force capable of transforming an enemy into friend.

Martin Luther King, Jr.

One loyal friend is worth ten thousand relatives.

Euripides

Let us be grateful to people who make us happy, they are the charming gardeners who make our souls blossom.

Marcel Proust

Don't walk behind me; I may not lead. Don't walk in front of me; I may not follow. Just walk beside me and be my friend.

Albert Camus

When we honestly ask ourselves which person in our lives means the most to us, we often find that it is those who, instead of giving advice, solutions, or cures, have chosen rather to share our pain and touch our wounds with a warm and tender hand.

Henri Nouwen

Friends are born, not made.

Henry Adams

A friend is one who knows you and loves you just the same.

Elbert Hubbard

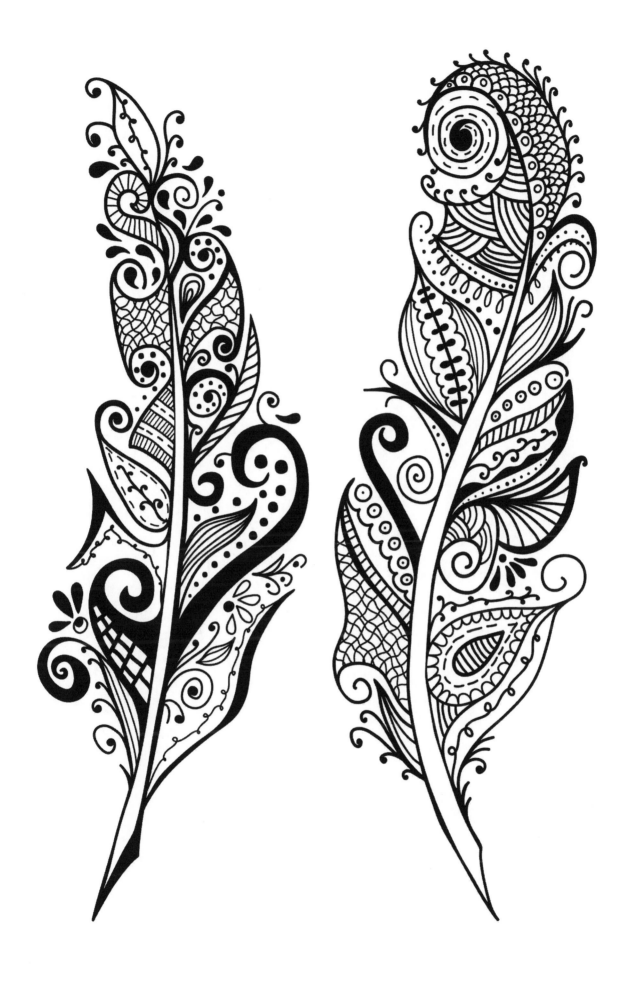

In the sweetness of friendship let there be laughter, and sharing of pleasures. For in the dew of little things the heart finds its morning and is refreshed.

Khalil Gibran

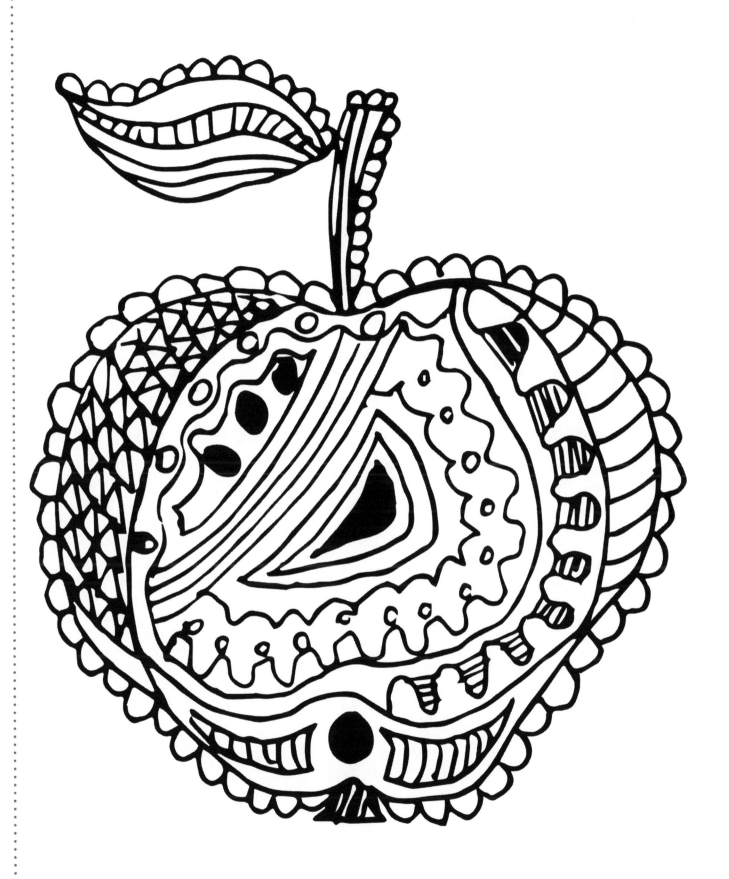

M

y best friend is the one who brings out the best in me.

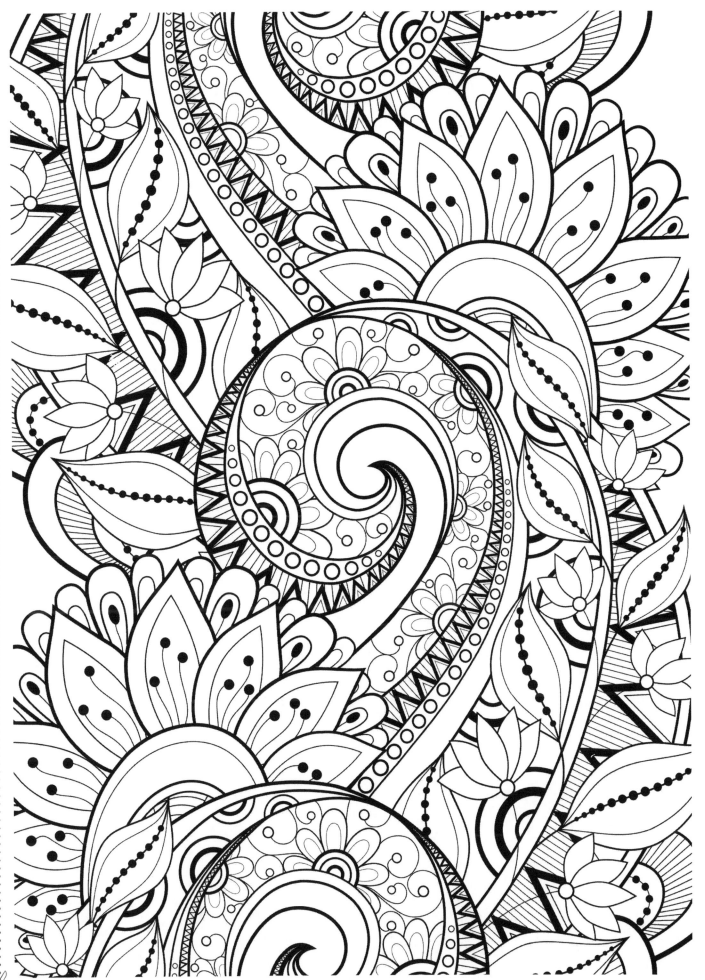

The world is round so that
friendship may encircle it.

Pierre Teilhard de Chardin

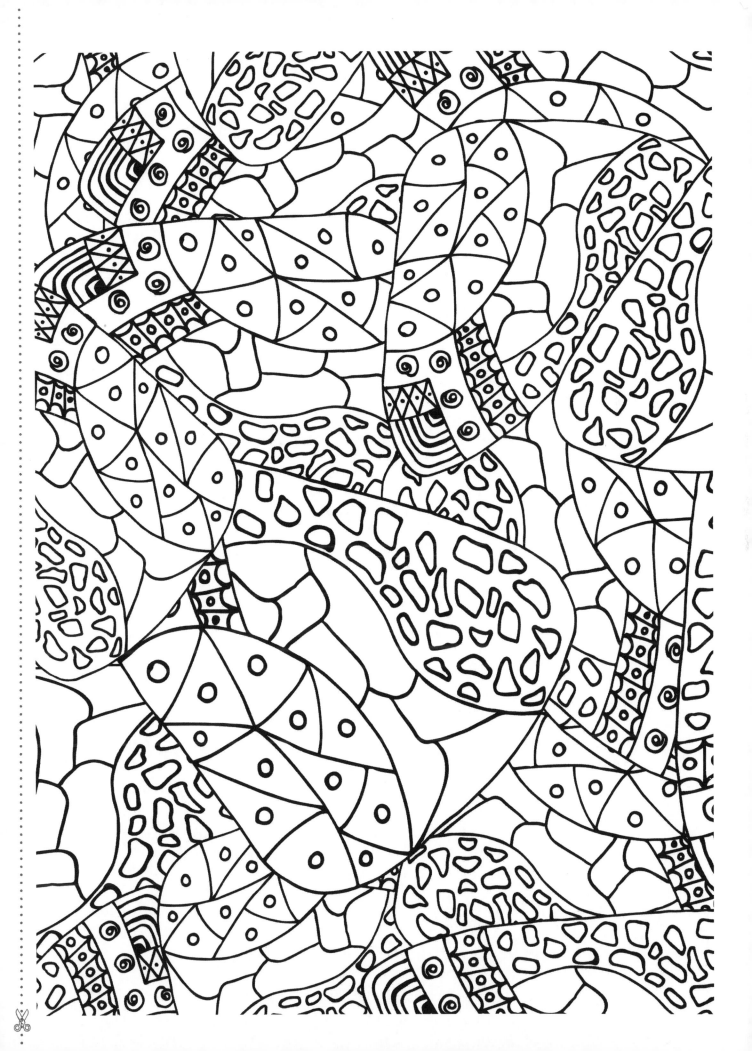

Friendship is one mind in two bodies.

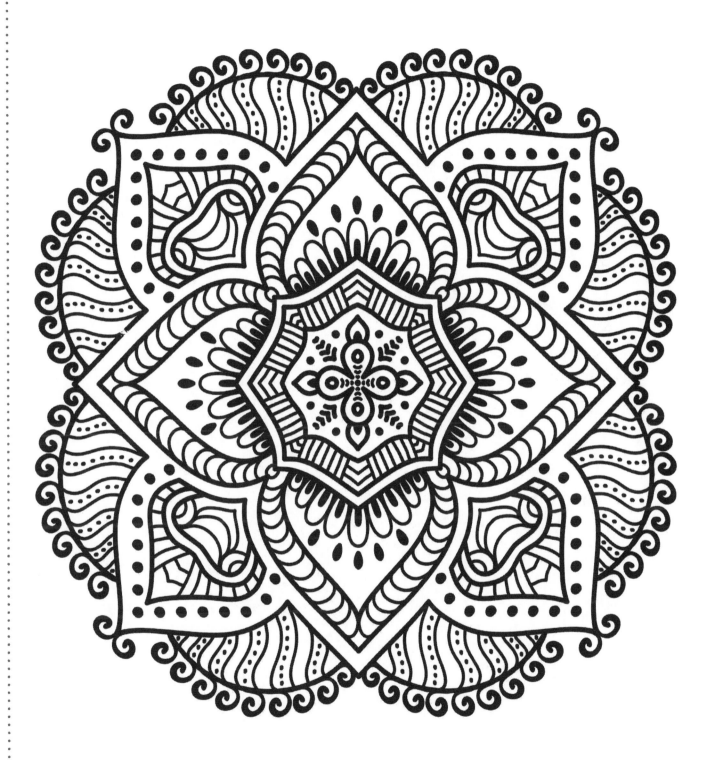

A friend is someone who gives you total freedom to be yourself.

Jim Morrison

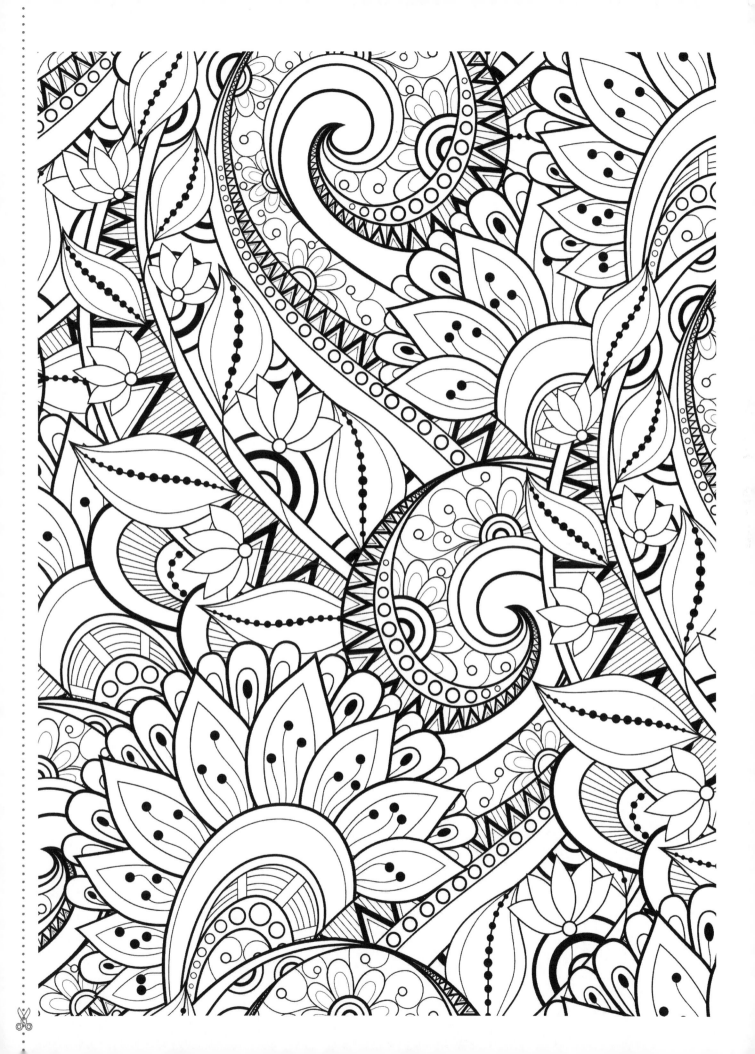

Your friend is your needs answered.

Khalil Gibran

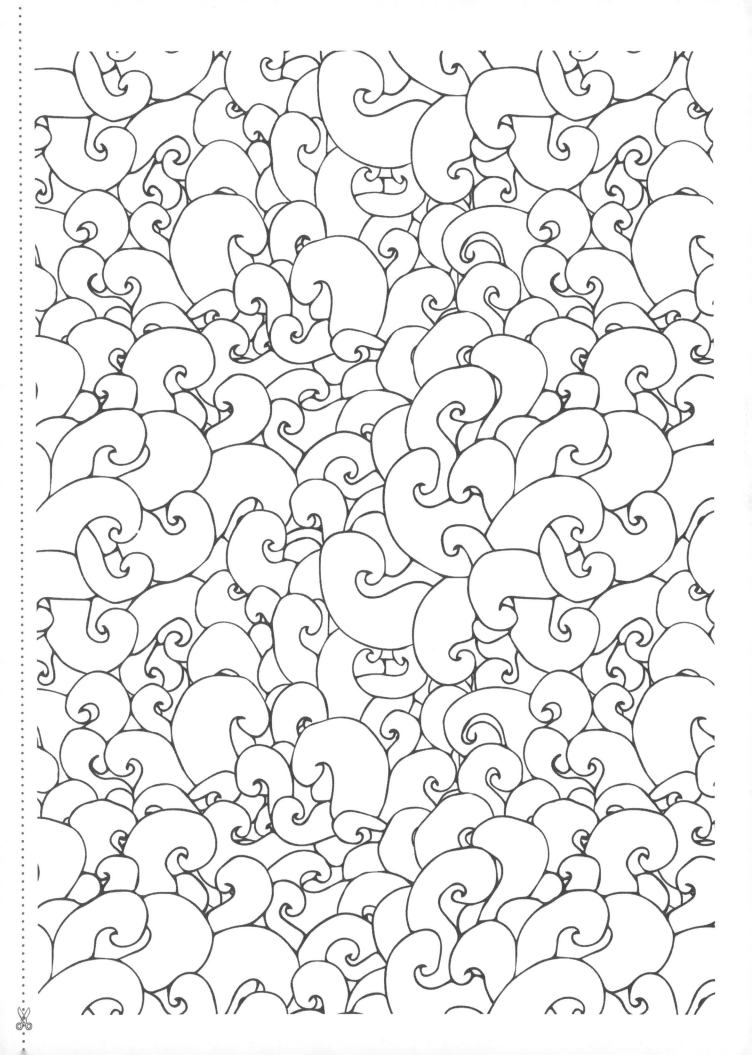

A true friend freely, advises justly, assists readily, adventures boldly, takes all patiently, defends courageously, and continues a friend unchangeably.

William Penn

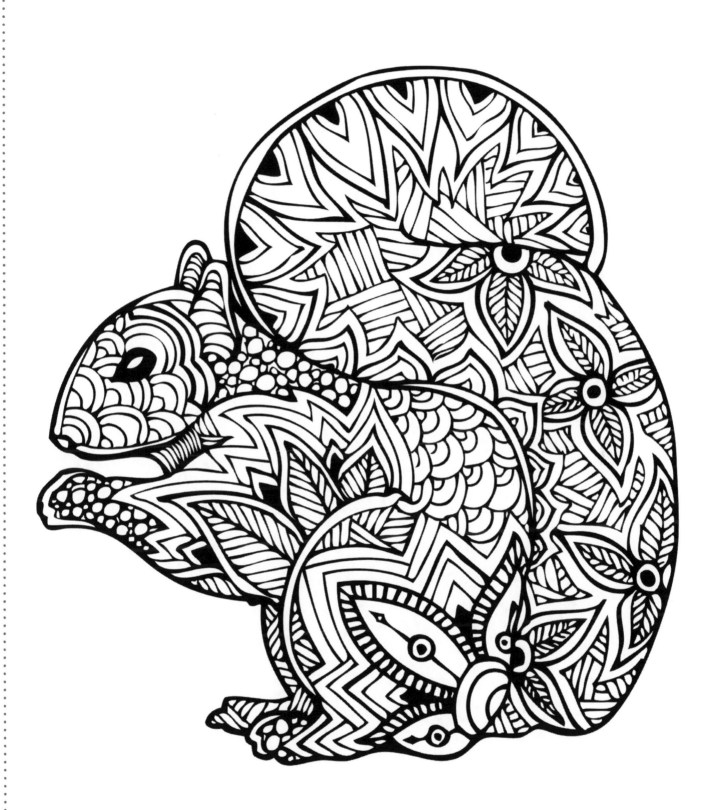

In everyone's life, at some time, our inner fire goes out. It is then burst into flame by an encounter with another human being. We should all be thankful for those people who rekindle the inner spirit.

Albert Schweitzer

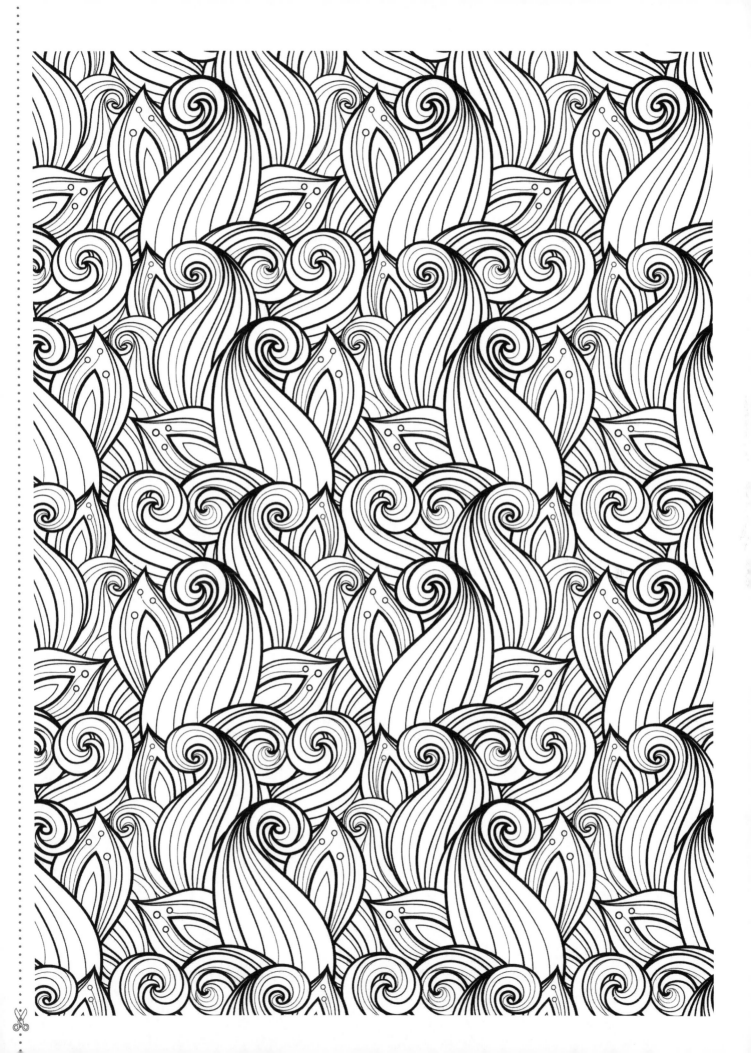

The only way to have a friend is to be one.

Ralph Waldo Emerson

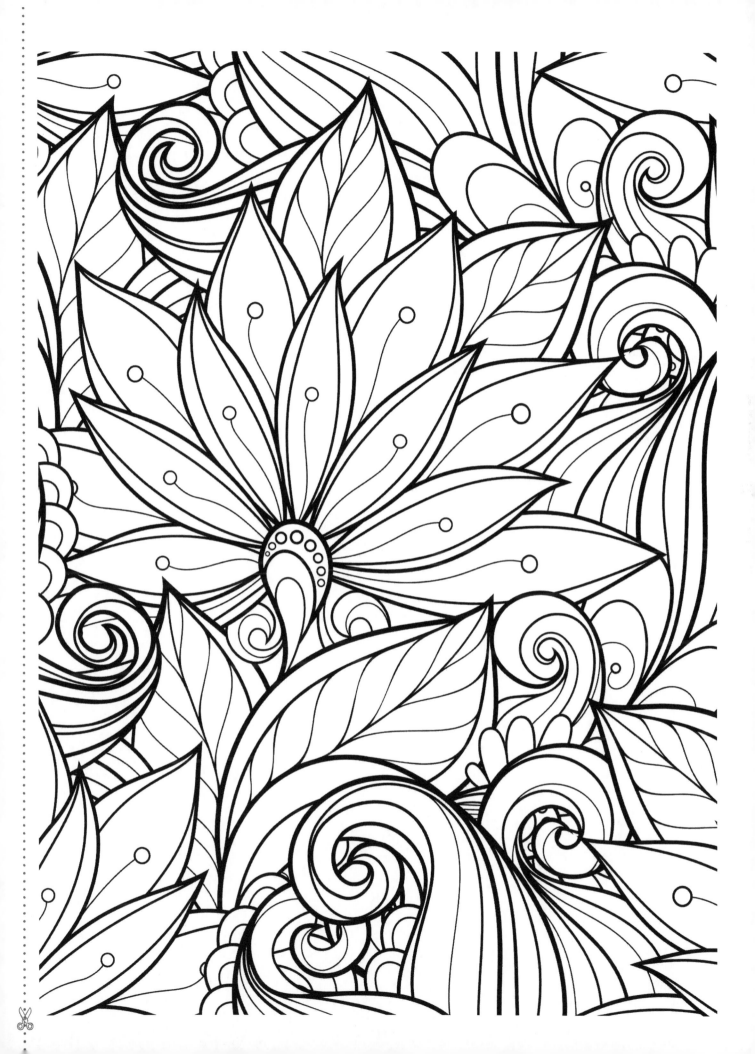

Things are never quite as scary when you've got a best friend.

Bill Watterson

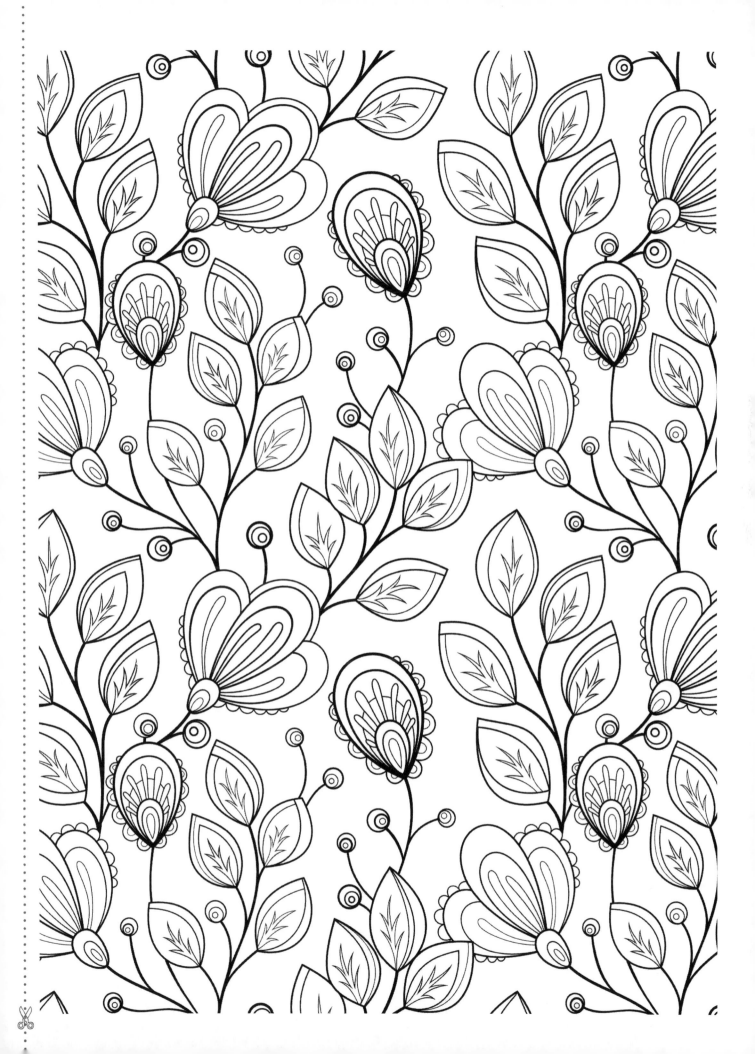

Friendship is unnecessary, like philosophy, like art... It has no survival value; rather it is one of those things that give value to survival.

C. S. Lewis

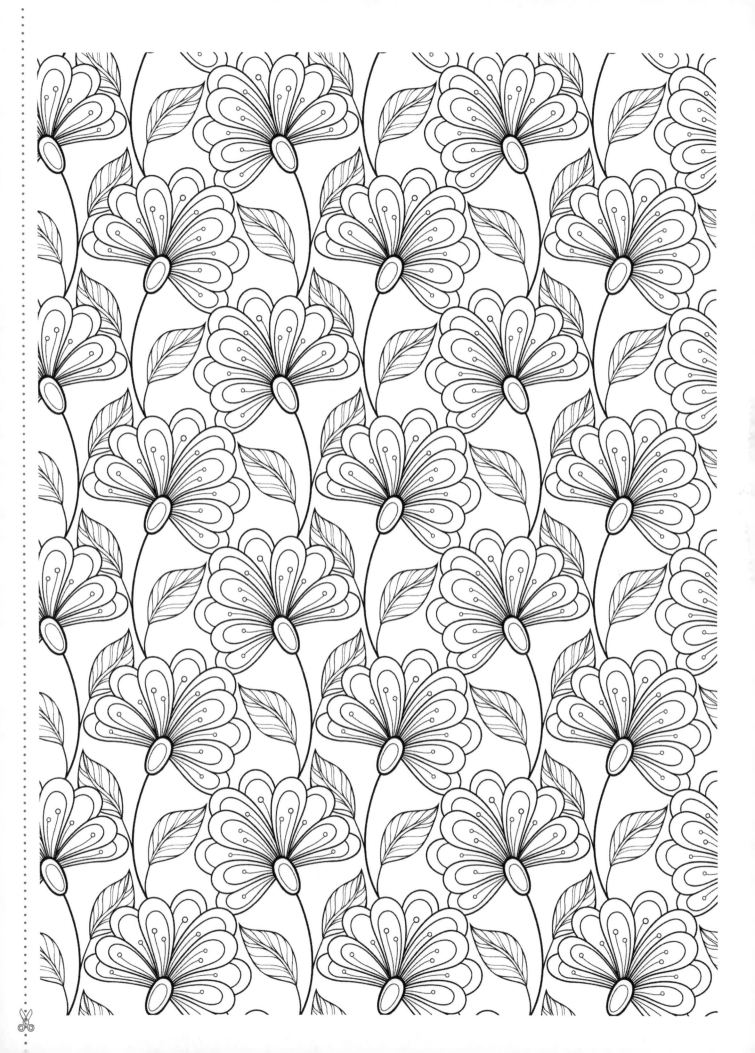

Friends and good manners will carry you where money won't go.

Margaret Walker

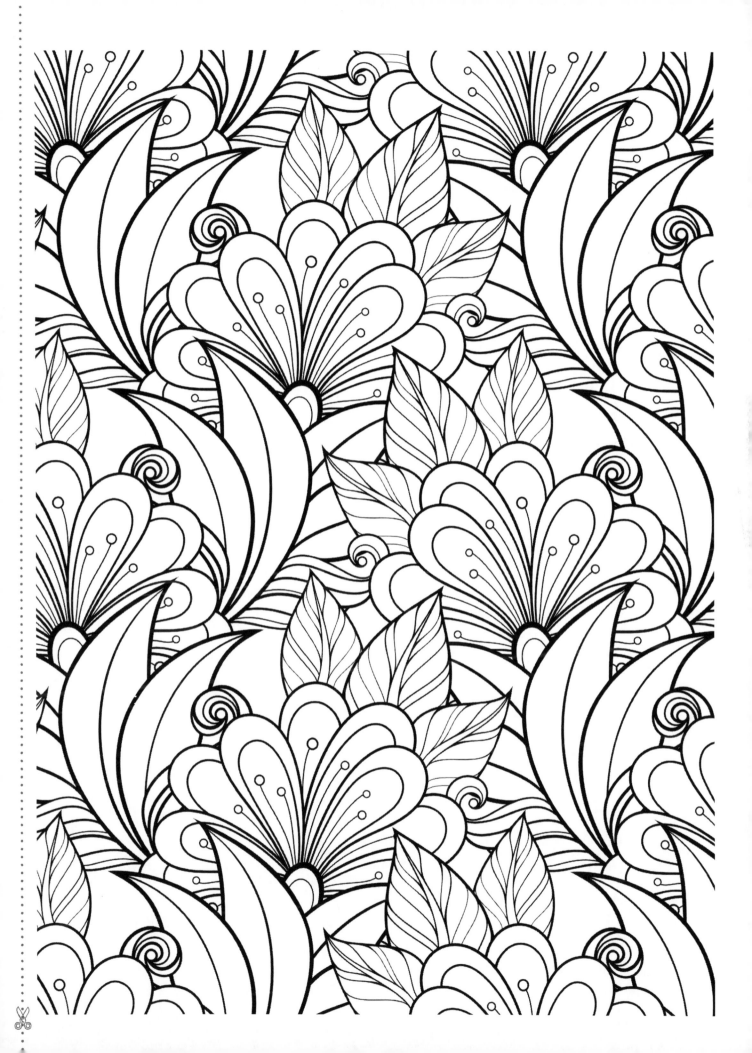

The best time to make friends is before you need them.

Ethel Barrymore

Printed in Great Britain
by Amazon.co.uk, Ltd.,
Marston Gate.